" He said, she says

The Power of Praying God's Word

by Allyson McElroy, On3Ministries
for Individual or Group Devotion

FREILING
PUBLISHING

Published by Freiling Publishing,
a division of Freiling Agency, LLC.

P.O. Box 1264
Warrenton, VA 20188

www.FreilingPublishing.com

PB ISBN: 978-1-956267-79-2
eBook ISBN: 978-1-956267-80-8

Printed in the United States of America

Dedication

THIS BOOK IS dedicated to the three most amazing, godly women I know. To my mother-in-law, Debra, who showed me life's storms can be lived out in peace as we put our faith in a loving Father. To my mom, Lynn. The most compassionate and caring prayer warrior you will ever know. I say "you" because there's a good chance you've been on her lengthy prayer list at some point. And to my Aunt Becky. The strongest and most-like-me person in the world. My book proofer and voice of reason. I love you all more than you'll ever know.

Table of Contents

Introduction

Who is "He"?

He said, She Says...

I STRUGGLED WITH the title of this book. The phrase "He said, she said" is usually spoken over broken relationships, with an arguing couple proclaiming "Well HE said..." followed by a rebuttal of "Well, SHE said..." No matter how or when you've heard it, it's usually stated about a relationship where two people are talking.

Exactly.

That's exactly why I stuck with this title that was in my heart long before I ever picked up a pen to write a single word. This book is about the *ultimate* relationship, where "He" is your loving, Heavenly Father, and "She" is you, the sweet, precious, woman-turned-friend who will join me in a few laugh-out-loud and tear-filled moments in the pages that soon follow.

God speaks to you. Present tense. And, as you'll discover, He wants you to speak back. He has given you powerful and precious words to proclaim over your life. He said them. Now it's time for you to say them.

1

Say It Again

Telephone Game

I LOVED STORMY days in fourth grade. When it was too muddy for outside recess on the playground, we'd drag out Mrs. Byers' stash of board games, old craft projects, and colorful chalk and spend an hour in that classroom doing something besides long division. Once we tired of Connect Four and chalkboard tic-tac-toe, Mrs. Byers would line us up for the best game of all: Telephone.

The game was simple: the student at the front of the line would whisper a phrase into the ear of the next person who would then whisper to the person next to her and so on until reaching the end. Whoever was at the end of the line would shout out, what was supposed to be, the original phrase. This never happened, of course. "A blue cat ran to a hat" usually ended up "A chewy rat can be a bat" and everyone rolling on the floor in laughter.

At the time, I didn't realize that Telephone game would follow me—us—into real life! How often have we heard something wrong or misinterpreted an overheard comment? How many personal battles and world wars have begun because of something that was or wasn't said?

But that's not what I meant!

I'm just going to out myself right here and use me as the biggest (worst) example of all. The year was 1998, and I was a freshman in college. I had just broken things off with my high school sweetheart. The relationship was over in every sense of the word, and I was at that "sure, we can still be friends" stage. He lived two hours away, so I was just waiting for him and that phrase to fade when he suddenly reappeared in my hometown.

Did I mention I met my would-be husband a week after that break up? We were just starting to date, but we both knew it was headed somewhere promising (more on that in a future book). It was 11 o'clock at night, and we decided to do what all college students do at that hour after studying for exams: head to an all-night diner for breakfast.

That's when my flip-phone-style cell phone rang. It was you-know-who, letting me know he was back in town. Now here's where I asked a question that I'll never in a million-years hear the end of from my loving and adoring husband. "Would you like to go eat with us?" I asked you-know-who, remembering my "let's just be friends" promise.

I didn't mean it. At all. I completely thought he'd say "No. I understand you've moved on and are hanging out with a new (better looking and more God-focused) guy." But did he? No. He misinterpreted my intent and, like the result of a bad game of Telephone, said, "Sure! I'll meet you there right now!" And just like that I was stuck at a syrup-sticky table in a burnt-coffee-smelling diner with a former boyfriend and a future husband. Ugh.

This chapter is for all of us (you know who you are) who have said something we didn't mean. It's for those who have misunderstood someone's intent. And it's even for those who have ended up at an ex's late-night breakfast table.

Speechless, literally

The book of Luke opens with a story that seems unbelievable. Surely Zechariah had misheard the conversation. Zechariah was way past the age most people had children. So was his wife. (Possibly knowing he should never call his wife "old," he proclaims "I am an old man and my wife is *well along in years*.") So, when an angel of the Lord told Zechariah he and his wife would have a son, Zachariah didn't believe him.

Then an angel of the Lord appeared to him, standing at the right side of the altar of incense. When Zechariah saw him, he was startled and was gripped with fear. But the angel said to him: "Do not be afraid, Zechariah; your prayer has been heard. Your wife Elizabeth will bear you a son, and you are to call him John. He will be a joy and delight to you, and many will rejoice because of his birth, for he will be great in the sight of the Lord. He is never to take wine or other fermented drink, and he will be filled with the Holy Spirit even before he is born. He will bring back many of the people of Israel to the Lord their God. And he

will go on before the Lord, in the spirit and power of Elijah, to turn the hearts of the parents to their children and the disobedient to the wisdom of the righteous—to make ready a people prepared for the Lord." Zechariah asked the angel, "How can I be sure of this? I am an old man and my wife is well along in years." The angel said to him, "I am Gabriel. I stand in the presence of God, and I have been sent to speak to you and to tell you this good news. And now you will be silent and not able to speak until the day this happens, because you did not believe my words, which will come true at their appointed time." Luke 1:11-20 (NIV)

Let me summarize:

Angel: Good stuff, good stuff, good stuff. Promises, promises, promises. Answered prayer, answered prayer, answered prayer.

Zechariah: Yeah, right.

Angel: If you're not going to speak truth and believe, then you're not going to speak at all.

I totally took my liberty with that last Angel part there, but that's basically what happened.

It's one thing to misunderstand a game of Telephone, but it's another to know what you hear and not believe it. I know what you're thinking: "I'd never do that! If an angel told me something, I'd believe it and proclaim it and tell the world!"

Are you sure?

The loudest whisper ever

Michael, the cuter guy on my accidental diner double date, married me in May of 2000. Seven years later, I gave birth to Michael's mini-me: a blond, blue-eyed boy we named Cole.

It was right before Easter, and Cole was three. Just a few months earlier, he'd learned the story of Jesus' birth, coloring manger scenes in the nursery class at church and loudly singing "Joy to da wor-ald!" in his Christmas program. Fast forward to March, and we sat quietly as a family in the sanctuary of our dimly lit, reverent, Easter communion service. Seeing the tiny juice cups and square wafers passed from person to person, Cole whispered, "Mommy, what is this?"

I thought I was doing good, able to share the gospel with my toddler. I leaned close to him and sweetly said, "This, son, is to remember that Jesus died…"

"He DIED?!?!" It was the loudest, most freaked-out whisper I'd ever heard. I didn't stop to think that, in Cole's mind, Jesus was still a baby, merely three months old. In his mind, the wisemen were still on their trek home, and Mary was still changing diapers. So to find out that poor little Jesus died completely broke Cole's heart.

I've never in my life corrected a story that fast and likely never will again. Clasping my hand over Cole's mouth, I quickly calmed him and told him that Jesus had grown up and given His life for us and… well, I don't recall how I finished the story in toddler language, but it was enough for Michael and me to contain our laughter and finish communion.

Misunderstanding… again

Two years later, Cole advanced to the "big kid class" at church. Graduating from sippy cups and fat crayons, he was now on to books-of-the-Bible songs, learning memory verses, and discovering the real meaning of the cross. Or so I thought.

It was one of the most gut-wrenching, heart-breaking, soul-searching car rides of my life because of one little conversation. We'd just pulled away from Sunday church as Cole shouted from the backseat, "I don't want to become a Christian!"

Pardon me while I try not to run off the road.

As much as I wanted to go old-school on him, jerk the car to the side of the road, and give him a whipping for even thinking such a thing, I composed myself to a state of Allyson-don't-you-dare-mess-this-up and let-Thy-wisdom-kick-in fast.

"Why?" was all I could think of.

His reply? "I don't want to die on a cross! Ever!"

"Son," I breathed a sigh of relief, "you don't have to die on a cross! Jesus did that in our place. In fact, He died so that we could live with Him forever and live in His blessings and promises! Romans 10:9 says, 'If you openly declare that Jesus is Lord and believe in your heart that God raised him from the dead, you will be saved' (NLT). That's all there is to it!"

I'd love to tell you that my words worked, but they didn't. Maybe his little brain couldn't comprehend it or perhaps another kid in class had told him otherwise, but he brought this same conversation up several times over

the next year until, finally, the second gut-wrenching, heart-breaking, soul-searching car ride happened.

"Mom," his little voice hesitantly squeaked from the backseat many Sundays later, "I'm ready to die on a cross."

I'm just going to stop right here and compose myself. I'm not going to ask how many of us would be willing to say that. No. I'm just going to grab my tissue, dot my eyes, and move on.

"Cole," I calmly and reassuringly said, "God loves you. He loves you so much that He doesn't want you to die on a cross. In fact all you need to do to be saved and become a Christian is to say that Jesus is Lord and believe that God raised Him from the dead. Are you ready to do that?"

"Really, mom? YES!"

So the two of us prayed: me in the front seat, Cole in the back, repeating a sweet prayer that so many have prayed for thousands of years.

Heavenly Father, I believe Jesus is Lord. I believe that You raised Him from the dead. I believe I am saved and will now live for You. In Jesus' name, Amen.

And, this time, he believed. It clicked. Something happened where the misunderstanding stopped. The bad game of Telephone where maybe one kid had told another kid that had told my son about self-inflicted crucifixion was ended. Cole followed Jesus' example and publicly declared his faith through baptism on January 8, 2014. A few months later, I logged this on my social media page:

Cole, out of the blue, while at the restaurant tonight, "Did you know that when Jesus was on the cross, everyone was looking at Him. But do you know what God saw? He saw all our sins on Jesus. Jesus did that for US!" April 23, 2014

Where do you fit in?

I pray that as you read this chapter and the pages that follow, you'll find yourself spiritually. You'll laugh, you'll cry, but, ultimately, you'll say, "Ooo, that was just for me."

Like now.

I don't know where you see yourself in this chapter. Maybe your life has been a bad game of Telephone. Maybe grandpa told grandma something about Jesus,

and grandma told mom, and mom told dad, and dad told you. Only when it got to you, it was as messed up as a "A chewy rat can be a bat." You've misunderstood what it means to be loved by God and to live in that love.

Perhaps you're like the diner-story me, saying spiritual stuff that you don't mean. Maybe you spout off promises about God and you quote Bible verses, but inside you don't believe they are true. You've led groups, led prayer, led in quoting John 3:16, but your words seem meaningless.

Maybe you're Zechariah. You hear promises of God and you read the word, but you don't believe any of it applies to you. No one knows what you've done, what you've been through, and what you're going through right now. Like Zechariah, you're figuratively speechless because you don't believe the promises apply to you.

Or maybe you're like Cole, with a mindset that surely becoming a Christian can't be that easy. That you have to *do* something hard to right your wrongs and be accepted by a Heavenly Father.

Say it again

I don't know where you fit into this chapter, but I'm asking you to ask yourself: "Where have I doubted? Where have I misunderstood? Where have I lacked faith?"

And, I don't know if you've prayed it before or never at all, but if you're ready, I'm asking for the two of us to pray. Me in the author's seat, you in the reader's seat, repeating:

Heavenly Father. I believe Jesus is Lord. I believe that You raised Him from the dead. I believe I am saved and will now live for You. In Jesus' name. Amen.

He said, she says

This is our first *He said, she says* moment. 2 Timothy 3:16 says, "All scripture is inspired by God" (NLT) and Hebrews 4:12 says, "The word of God is living and powerful" (NKJV).

Each time you say the words from the scripture, you're speaking living and powerful words of God, your Heavenly Father. As we read on, I want to encourage you to speak—aloud—verses that you read in these pages.

They are alive, powerful, and for you from your Father. He gave them to you to bless you (Yes, He wants to bless you!). He gave them to you to heal you (Yes, He wants to heal you!). He gave them to you to restore you (Yes, He wants to restore you!). He said them, now you say them, totally trusting and believing in His Word.

For personal devotion or small group study:

(Consider sharing your answers with others)

1. Do you recall a time you misunderstood someone and it ended in laughter? Write/tell about it.

2. What's something you thought as a child that seems unreasonable now?

3. Write about the time you accepted Jesus as your savior and prayed a prayer similar to the one above. If today was your first time or if you're fully recommitting your life with those words, tell someone.

4. Look up these verses and write what they mean to you for your current life situation. Say them out loud as you write them.

Romans 10:9

Ephesians 2:8-9

1 Peter 2:2

2 Corinthians 5:17

2

The Loudest Cheer

Be Careful Little Tongue…

IT'S A WONDER that we all didn't have Cole's misconception about all-things Bible. By "we" I mean, of course, me and all the children growing up with rhymey childhood Sunday School songs. Aside from the traditional, "Jesus Loves Me," most of the other songs were a bit, let's say, confusing:

> *The devil is a sly old fox.*
> *If I could catch him I'd put him in a box.*
> *I'd lock that box and throw away the key,*
> *For all those tricks he's played on me.*

Why are we singing songs about the devil, let alone his power to play tricks on us and telling kids they can't prevent it? SMH…

I'm in the Lord's army! I'm in the Lord's army!
I may never march in the infantry,
Ride in the cavalry, shoot the artillery
I may never fly over the enemy
But I'm in the Lord's army.

Ladies… I wore frilly dresses and bows in my hair. I was afraid of guns and thought the word "infantry" had something to do with the baby nursery down the hall. I did NOT want to be in an army!

But, as much as those songs could confuse me, here's the kicker:

O be careful little tongue what you say
O be careful little tongue what you say
For the Father up above is looking down in love
O be careful little tongue what you say

For those of us who had just had a screaming tantrum in the hallways before being dropped off at the door to Sunday School, this song was a threat. Sing it back through with that third line being yelled at you by the pointy-fingered witch from The Wizard of Oz and you've pretty much got my frame of mind.

I hope most of us made it out of the five-year-old class unscathed and mentally unscarred by such songs and, instead, remember the gold stars for knowing memory verses, the smell of glue and Graham Crackers (although not mixed together), and the feel of broken crayons between our fingers.

Masterpiece

Even if you never set foot in church as a child, I hope you learned somewhere along the way that God loves you. At some point between the "Jesus loves me, this I know" and the gluing of cotton clouds and glitter rain on a picture of Noah's Ark, I realized that not only did God love me, but He wanted good for me. He had and *has* a purpose for me.

I'm not sure why we never had brand new crayons in that kindergarten Sunday School class. What we did have were buckets of fat, skinny, and even pyramid-shaped broken crayons, all missing their wrapped, paper labels. During class, I'd draw bright rainbows, big blue raindrops, and triangle-roofed houses. When Mom came to pick me up, I'd beam with pride as I handed her my masterpiece.

As an adult with a child of my own, I realize that there's a good chance Mom had no clue what I drew. Have you ever been handed a piece of "artwork" painted by a child? She's so happy and pleased with herself! Colors and lines and glitter cover the crumpled paper. Stick figures require head tilts to determine if they are people or trees. But the little artist knows exactly what it is, even if you don't. "Don't you just love it?" she asks, beaming with a smile. She's proud, even if you aren't. Why? Because she created it.

God is the best artist of all. Ephesians 2:10 says, "We are God's masterpiece" (NLT). God is so pleased with His creation—you. He can't wait to show you off. He knows exactly who you are and the purpose He created for you. The verse goes on to say that He created us to "do the good things he planned for us long ago."

You might be tilting your head at your scribbled life right now. You might be wondering how God could create someone like you. How God could use someone like you. How God could love someone like you. But He did, He will, and He does. He's beaming with pride at you, His creation, asking, "Don't you just love you?"

I don't know if you answered a resounding "YES!" to that, or if you're speechless, but He is the ultimate Creator

and Artist. He never makes mistakes. And He always has a purpose for his masterpieces.

Xs

People think I tell stories about my son. I'm actually telling stories about my attempts at parenting. Think about this: if you've never ridden a bike, you get training wheels and a helmet and even a flat, straight road for practicing. But with a new baby? They just put him in your arms and say, "Here you go!"

This becomes evident when that child reaches the age of three or four, when "official" discipline starts. Michael and I were trying to decide the best way to correct Cole when he threw a tantrum or ran away from us in the middle of Walmart. Spanking? A behavior chart? Time out?

At some point, though, you no longer have time to decide, and that parental gut the hospital packed in your diaper bag kicks in. "I'm going to give you an X!" I exclaimed after one of Cole's screaming fits.

An X? What on earth was an X and where did that statement even come from?

I didn't know what an X was, but apparently he did. That's all it took. I would threaten with "an X" and he would straighten up, quiet down, and obey my every word. Wow... this was going to be easy!

This worked so well that we never even made it to the behavior chart or time out. I was about to write a book on my newfound expertise of child discipline when I had an epiphany.

Cole and I were curled up watching old cartoons one Saturday when I noticed something. Every time the animated coyote ran headfirst into the dynamite, his eyes turned to big, black Xs. Ugh. Y'all, my kid thought I was threatening to kill him.

Book idea thwarted.

The biggest cheerleader

Last I checked, God doesn't give out Xs. God doesn't own a thick, red marker for putting check marks by your name on a heavenly whiteboard. He's not basing His love of you on what you did or didn't do, have or haven't done. Romans 5:8 tells us that "God shows His love for us in that *while we were still sinners*, Christ died for us" (ESV).

God doesn't give out Xs and He doesn't give out disclaimers. His Word doesn't say, "The Lord will withhold no good thing" from us *unless we're former addicts.* His word doesn't say, "The Lord will withhold no good thing" from us *unless we've just been diagnosed with cancer.* No, Psalm 84:11 says, "The Lord will withhold no good thing from those who do what is right" (NLT).

God doesn't require perfection. In fact, Paul, who wrote much of the New Testament, wrote, "I don't mean to say... that I have already reached perfection. But I press on to possess that perfection for which Christ Jesus first possessed me" (Philippians 3:12, NLT).

God's not pointing His finger, like a threatening children's song, just waiting for you to mess up, but He is ready to love you when you do. He's not giving out Xs and giving up on you when life runs into dynamite. He loves you, His masterpiece. Even though you may not believe the picture of your life right now, He is still drawing, creating, planning your purpose. And it is good.

God wants good for you, and every promise in His word is yours. 2 Peter 1:4 tells us that, "He has given us great and precious promises" (NLT). He's your biggest cheerleader. He's leading the "You've got this!" shout.

He's calling out from his Word, "I will give you strength!" (Philippians 4:13) and "I care about you!" (1 Peter 5:7).

Are you listening?

God loves, wants good for, and has a plan for the woman who is focused.

God loves, wants good for, and has a plan for the woman who is driven.

God loves, wants good for, and has a plan for the woman who is confused.

God loves, wants good for, and has a plan for the woman who is divorced.

God loves, wants good for, and has a plan for the woman who is married (happily or un).

God loves, wants good for, and has a plan for the woman who is widowed.

God loves, wants good for, and has a plan for the woman who is alone.

God loves, wants good for, and has a plan for the woman who is sick.

God loves, wants good for, and has a plan for the woman who is depressed.

God loves, wants good for, and has a plan for the woman who is scared.

God loves, wants good for, and has a plan for the woman who is giving up.

God loves, wants good for, and has a plan for the woman who is childless.

God loves, wants good for, and has a plan for the woman who is weak.

God loves, wants good for, and has a plan for the woman who is strong.

God loves, wants good for, and has a plan for you.

He said, she says

Let's pray aloud the very words of God. Let's say what He said:

Heavenly Father, forgive me for thinking anything about myself that is less than what You think of me. You call me masterpiece. You call me blessed. You have given me promises and are for me and for my good. Today, I commit to believing that You have a plan and purpose for me and that Your Word will empower and equip me to do good. Thank You. In Jesus' name I pray, Amen.

For personal devotion or small group study:

(Consider sharing your answers with others)

1. How would you answer the question if your heavenly Creator asked, "Don't you just love you?"

2. There's a good chance you know a woman—possibly even yourself—who would not answer that question with "yes." What would you tell her (or yourself) about how God, the perfect Creator, sees her/you? Write down what God thinks about you based on these verses:

 Ephesians 1:3

 Psalm 139:17

2 Corinthians 5:17

Ephesians 2:10

3. God doesn't require that we know the purpose (good works/plan) He has for us, only that we trust Him with the next step. Read the following verses and write down what God says about our next steps:

Psalm 37:23

Psalm 40:2

Psalm 119:105

Proverbs 3:5-6

3

Voices in My Head

Elby, Jeanie, and Shawna

MY BEST FRIENDS at age four were Elby, Jeanie, and Shawna. They never left my side—ever. Jeanie was a joiner. She played what the other girls wanted and never argued. Her curly hair bounced as she jumped with me on my mini trampoline and ran through the backyard. Shawna looked the most like me. With straight, blonde hair, she was the only one who could fit in the passenger seat as I drove my orange and yellow Little Tykes car through the kitchen. But it was Elby who stuck around the longest. Elby was mischievous and seemed to always take rules to the limit. Even after Jeanie and Shawna grew up and left, Elby stayed around until I was six or seven.

My imaginary friends.

I wonder what my poor mother thought when I paraded through the house, talking nonstop with my gang of invisible playmates. I knew they weren't there

in real life, but it didn't matter to me. With this group, I was the winner of every game of Chutes & Ladders. I was always in charge of picking the Cabbage Patch doll who needed a boo-boo bandaged.

Somebody please tell me you had a group of made-up playmates too. Surely I'm not the only one who invited invisible friends to tea parties and blamed imaginary partners-in-crime for my wrong doings. Right?

Imaginary... *disease?*

I suppose my imagination didn't mature as quickly as those friends. Fast forward nearly FORTY (yes, 40) years as I sat in the car with Cole at the automatic car wash.

It had been a great day. One of those play-outside, splash-in-the-mud-puddle days. You know it's a good day when everyone's messy and dirty and still smiling about it. While I cleaned the house, I sent Cole to take a long, hot bath, even letting him use my new lotion for his weather-chapped skin.

Just when I thought everything was clean and back in order, I noticed my car had also been a victim of the fun. Cole and I loaded up and drove straight to the automatic

car wash. He was talking non-stop about the day and I was loving listening to every minute of it.

Until, that is, a huge pit came in my stomach. Something was wrong. My freshly bathed pre-teen didn't look right. His hands and arms were splotched, as though fresh from the dirt pile. I did the traditional mom-spit-on-finger move and tried to scrub the patches of brown from his skin. Nothing changed. The brown spots still dotted his arms like discolored rashes. My heart rate increased as I pretended to listen to Cole's stories from the day while actually rummaging through mental images of rushing him to the ER for, what was surely, "instant skin pigmentation disease." I Googled everything I could think of. *Skin discoloration. Pigmentation issues. Side effects of too much mud.* What was wrong with my child?

I decided the ER trip should wait to see if other issues came up. For the next thirty minutes I stared at him, analyzing every burp, every blink, and every cough. Pulling back into my garage, I and my worry-filled mind silently walked through the house. I decided to go to the area near the bathtub where I kept all the soaps and cleansers, just in case one of them would turn my kid back into himself. That's when I saw it.

Right next to the new body lotion I had loaned Cole, there was a second bottle, nearly identical in shape and size: self tanner. Instead of moisturizing his dry skin, my kid had fake-baked himself! Nearly half his hands and arms were now Beach Ready Bronze and would stay that way for five to seven days. No ER trip needed.

Grown up imaginations

I'd like to say I prayed during that tumultuous hour or so, but I don't know that I did. I'd like to say that I quoted healing scripture and saw warring angels in my spirit, but nope. I was the epitome of what needed to be destroyed in Paul's verses from 2 Corinthians 10:3-5. If it's okay with you, I'm going to quote from the *New Living Translation* of the Bible, but in parentheses I'm going to add a few synonyms from other translations:

We are human, but we don't wage war as humans do. We use God's mighty weapons, not worldly weapons, to knock down the strongholds of human reasoning and to destroy false arguments. We destroy every proud obstacle (imagination, sophisticated argument, reasoning) that keeps people

from knowing God. We capture their rebellious
thoughts and teach them to obey Christ.

While the "their rebellious thoughts" part shouldn't be referring to me here, it certainly is! How often do we keep *ourselves* from knowing God and His power because of our own proud obstacles, imagination, sophisticated arguments, and reasoning?

Whale of a thought

I know we'd all like to say that we'd never be like Jonah, but I kindly beg to differ. Just like Zechariah, Jonah was told something that was "God's Truth" and, instead, believed—or imagined—"Human Truth."

In the first chapter, Jonah received a direct order from God to go to the city of Nineveh and give them a message. Logic and faith tell us that if God told him to go and give a message, that God would see to it that Jonah arrived safely to fulfill his purpose. But Jonah looked at human truth. He knew the town of Nineveh was a city of over 120,000 "living in spiritual darkness." In other words, this was a bad place for a Hebrew who worshiped God. No doubt Jonah imagined torment and despair. Would

they jail him upon arrival? Would they torture him with whips and chain him in a dungeon, gouging out his eyes and pulling out his hair?

Nothing Jonah imagined was likely too far-fetched. Given the suffering mentioned in biblical accounts of prisoners, Jonah's what-ifs *could have become reality*. *Humanly* speaking.

But God said, "Go," and when God says "Go," that means He'll provide a way to go, a place to go, and make sure you get there.

So, when Jonah let his whale-sized fears overtake him so much that he ran away, God sent a whale-sized fish as transportation for a U-turn back to the promise. Aren't you glad God is the God of second chances (and third, and fourth, and…)?

Struggle salad

Remember Elby, Jeanie, and Shawna? Those three loved to make dinner with me in my backyard. With a tiny bowl in one hand and a handful of grass in the other, we'd make my specialty: salad. Green weeds for the base, yellow dandelions for garnish, and sand for the salad dressing.

My only customer was my daddy, who would pass by my makeshift kitchen on his walk from the back porch to his workshop. He always stopped to sample my menu and always amazingly cleaned his plate (by dumping it on the ground while I wasn't looking, of course).

Sometimes my mind and body and emotions feel like that salad. A bit of worry here, add in some aches and pains as garnish, drizzle on guilt and insecurity, and add thoughts of loneliness for good measure. But just like that weed salad wasn't good for me, neither is this struggle salad.

Wouldn't it be great if our Heavenly Father would just dump it while we weren't looking? But that's not how it works. Let me loosely but powerfully retranslate 2 Corinthians 10:3-5 into Allyson lingo and add in a bit of Ephesians 6:

I am human, but I'm not supposed to battle like humans do. I'm supposed to use God's weapons. (And He gave me the sword of the spirit, which is the Word of God.) I am to use this mighty, always-winning weapon to battle strong fears that try to keep me from being empowered by God. I am to use the Word of God to destroy any physical or

mental or spiritual sickness that tries to prevent me from fulfilling God's purpose for me. I am to capture my insecure thoughts that, though powerful, rebel against God's best for me. I am to capture thoughts that, basically, call God a liar because they do not match what He says in His word. It's my job to align my thoughts with His Word.

Read that again.

Pretend I'm standing up at a conference full of broken and battle-worn women, proclaiming that exact retranslation in a powerful, compassionate, motivational voice. Everyone stands and cheers, hands in the air praising God!

And that's great. But hang tight. Because that's not the scenario. This is just me and you or just me and your small group of ladies, being real and raw.

Because, if it's not sunless tanning lotion causing us grief, it'll be something else. And if it's not me Googling some made up disease, it'll be me researching a future pandemic. And if it's not thoughts the size of a whale, it'll be thoughts the size of a tiny yet annoying, unswattable mosquito that just won't go away.

Our thoughts never seem crazy in the moment. Our fears never seem unwarranted at the time. Our guilt never seems unfounded when something happens. Our mental and physical sickness always comes with mental and physical battles. Looking back, the tanning lotion story seems crazy, but it was so real that day. Looking back, Jonah's fear causing him not to trust God seems irrational, but it wasn't to him. So, how do we dump our mental weed salad?

Empowerment: silencing the voices in my head

I always dreamed of taking my backyard salad-making a step further: baking, for real, in the kitchen. A while back, I scoured social media for the best bread recipe I could find. The recipes called for special pans, techniques I'd never heard of, ingredients I'd never even seen, and for prep and baking time that I didn't have. My baking attempt was over before it ever began.

A few weeks later, I had an actual free weekend with nothing on the Saturday schedule. This was it. This was the day I would bake bread. I planned my shopping trip in advance, adding yeast and rosemary and cornmeal to

my grocery list. I ordered the best baking sheets and loaf pans online, making certain they'd be delivered in time.

Saturday came. Saturday went. I hadn't even turned on the oven all weekend.

I can tell you all day long that I'm a baker. I can tell you that I have the oven and the pans and the ingredients and even the time, but until I pick them up, put them all together, and actually bake, I'm just sitting on the couch surfing social media.

You are empowered. I can tell you all day long that you're empowered. I can tell you that you have all the tools you need to defeat and defend and destroy any thought that doesn't line up with the Word of God and His best for you. But until you pick up the Word and read and speak it, you're just a woman on a pew, in a seat, in your car, lying in bed.

And just like you can't come to my house to mix and stir and knead and bake on my behalf, then call me a baker, God can't pick up the sword of the Spirit for you and be a conqueror on your behalf. His Word says in Romans 8 that **you** are *more* than a conqueror. Do you feel like it? Are you winning?

2 Corinthians 10 tells us that WE wage war. WE use God's weapons. WE destroy false arguments. WE destroy

imaginations. WE capture rebellious thoughts. Ephesians 6 tells US to put on the armor of God. WE take the sword of the Spirit which is the Word of God.

WE – Not God. Instead, your God has given you every tool you need for the battles of life. He's equipped you to destroy your negative and worry-filled thoughts. He's empowered you to overcome what seems logical and humanly possible.

He said, she says

Let's pray aloud the very words of God. Let's say what He said:

Heavenly Father, I thank You that you have empowered me so much that you call me "more than a conqueror" in Romans 8. Father, sometimes I don't feel victorious. Sometimes thoughts come up that seem very real and life stares me down. Sometimes my mind swarms and my imagination runs wild. I pray that, when that happens, Your Holy Spirit will guide me back to 2 Corinthians 10, which reminds me to use my spiritual weapon to capture, defeat, and destroy any thought that is

*against Your best for me or against Your promises in Your Word. Ephesians tells me that the Bible is my spiritual weapon. Forgive me when I don't use it enough or even at all. When I use your Word, I **am** more than a conqueror. Thank you. In Jesus' name I pray, Amen.*

For personal devotion or small group study:
(Consider sharing your answers with others)

1. Battles often come when we feel weak. When do you *not* feel like you are a victorious conqueror?

2. Verses in Psalm 119 tell us we should store up God's Word and use it as a lamp to guide us. How can we "store up" verses and allow them to guide us when we feel weak?

3. Knowing that you are empowered to battle, what's one thing you can do over the next five days to equip yourself for any struggles you might face?

4

You're on Speaker

Speaker phone

A FEW YEARS back my grandma—lovingly named
"Meemze"—was suffering from Alzheimer's. The funny
thing is, "suffering" wasn't the right word. See, Meemze
never knew she had Alzheimer's. She only knew she was
staying hotel-style in my mother's home and being chauf-
feured instead of driving to her favorite fast-food locales.
(Perhaps it was the day she mistook the first green at the
County Club golf course for McDonald's drive up window
that convinced us it was time to hide her keys...) She
whistled loudly to all the tunes in her head and cheered
for both teams at every one of Cole's baseball games.

Each morning at 9:30, I made a habit of calling my
mom to check on Meemze. Had she slept well or gotten
up in the night, seeing lions in the living room again?
Was her morning spent watching her beloved soap opera
or asking the same questions over and over? And it was

one such phone call that nearly got me kicked out of the family. My mom answered: "Hello?"

"Well, is she being crazy today?" I asked with the loving humor one must have with such a situation.

Silence… then, "You're on speaker."

It was then and there that I realized mom had placed me on speaker phone with oblivious-to-her-diagnosis Meemze only two feet away. After a bit of backtracking and well-crafted questions, we both realized, with relief, that Meemze was zoned out and hadn't heard my no-longer-funny opening line.

"You're on speaker." I don't know about you, but being put on speaker is my pet peeve. Anyone else out there shouting a resounding "Amen"?

Know who's listening

I digress, but kind of on purpose, because, guess what? You are on speaker right now to an audience of one: you. And you are listening to every word. Your soul, your heart, your mind, your health, your relationships—*everything within you is listening.*

In 1 Samuel 17, we see this truth in action. We all know the story of David and Goliath. But let's start at the

beginning. David, a shepherd, stayed with his flock while his older brothers traveled to the warfront. One day, David's father asked him to take bread and supplies to his brothers on the battlefield. When he arrived, David heard the shouted threats of a massive man—a giant—named Goliath whose mere taunts sent the armies fleeing. That was Goliath.

But what about God? Who was God to David? David couldn't Google "Who is God?" and there was no New Testament to reference. For David to know God, he had to have an intimate relationship with his Heavenly Father. And he did. We know from scripture that David defined God as his rescuer. He defined God as the one who rescued him and the one who saved all that was important to him (see 1 Samuel 17:37). And—here's the kicker—David had a definition of God long before he had a definition of his problem, Goliath.

Did you catch that? David knew more about his God than his problem. Can we say that about all the mishaps and trials in our life?

Not only did David know about his God, but he *spoke* about his God in Psalms and songs and even to the king. In Psalm 3, David says "You, O Lord, are a shield

around me" and in Psalm 4, "You alone, O Lord, will keep me safe."

David knew that in order to defeat a giant, he needed his words to match up with **THE** Word. If he believed the words he wrote and he believed his testimony of his Rescuer, then his spoken words had to match up. He needed his description of what was in front of him to match the description of what was within him, and he needed to proclaim it.

When talking about Goliath, David didn't say, "Wow, this dude is massive. How will anyone ever take him down?" David didn't say, "Everyone is terrified, so I should be terrified too!" No, David said, "The Lord who rescued me from the claws of the lion and the bear will rescue me from this [giant]!" (1 Samuel 17:37). And, in that one spoken sentence, David's mind and his actions came into alignment with the definition of his God.

David used his words as weapons and destroyed Goliath *in his mind* long before he ever set foot on the battlefield. Ephesians 6:12 says, "We are not fighting against flesh-and-blood enemies, but against evil rulers and authorities in the unseen world, against mighty powers in the dark world, and against evil spirits in the heavenly places" (NLT).

Through the words he spoke throughout 1 Samuel 17 we can see David's audacious boldness and determination that he could and would defeat his foe. David's confidence in defeating his giant was not in his muscle or his might, but in his words and his worship. He knew his God was a rescuer and redeemer, and he spoke that aloud.

Are your spoken words lining up with THE word? Are your actions in agreement with what God says about your situation?

Alignment = Truth

Giants are all around us. They might be big, but they also could be small. Take, for example, the cow dog living next door. To me, BJ the dog (Brownie Junior) is a playful country dog who stays outside of the neighbor's home, barking at their horses by day and howling with the coyotes by night. But to an age-seven Cole, he was a giant, meat-eating predator.

Cole never told me he was fearful of BJ, and I really don't think he was until one Wednesday evening right before sunset. It was Cole's turn to take out the trash. Living in the country, that task meant rolling the trash can from the garage up the long driveway to the county

road at the top of the hill. And guess whose fenceless yard touched the side of our driveway? BJ's.

Here's what I knew that Cole didn't: BJ wore a remote training collar that gave him a tiny vibration and beeping noise if he got too close to his electric, invisible fence. BJ had never once crossed that unseen line.

So, as Cole hesitantly rolled the garbage toward the top of the hill, BJ peered from his porch. And the more racket those squeaky trashcan wheels made, the more irritated BJ got. Then it happened. BJ charged straight toward Cole, ready to pounce. At the very moment BJ reached the boundary of his invisible fence, Cole placed his hand in the air and authoritatively commanded: "STOP." And, as though in perfectly timed obedience, BJ came to a screeching halt.

"Wow…" I heard Cole mutter in amazement as I watched from the garage door.

What words had I spoken over Cole before his trek up the hill?

"BJ is huge!"

"Have you seen what that dog does to his stuffed toys?"

"Wow… I've never heard a bark that loud!"

No. While all of those statements *would have been true*, what I said to Cole was what aligned with the greater truth I knew: "You'll be fine. BJ won't hurt you."

So, when BJ charged at Cole, Cole didn't scream for help. Cole didn't say, "He's so big! Get me outta here!" No, Cole simply and confidently said, "STOP." His words and actions aligned with the truth he believed from his mother.

Are your words and actions about your giant aligning with the truth you believe from your Father and from His Word?

The power of the tongue

I've shared that story many times with those who will listen. I imagine Cole thought he was a cape-wearing superhero that day with powers to stop any make-believe monster in its tracks. And I'm okay with him thinking that, because imaginary and real giants are everywhere!

I don't know about you, but my thoughts can start running faster than BJ's attacking charge. My thoughts WERE my giants when I was young. A freckle on my arm went from cute little birthmark to full-blown, stage four cancer within a few mental what ifs. And, in a worrisome

moment, a splinter in my big toe turned into a pending amputation.

God knew and knows our thoughts are not His thoughts (See Isaiah 55:8-9), so He asks us to *speak* His thoughts and His words. Swinging our spiritual sword by saying scripture is powerful, especially when you are the one listening.

Proverbs 18:21 drives this point home to a level only the Bible can reach: "The tongue can bring death or life" (NLT). I love it when the Holy Spirit just sums up what I'm trying to say in one, in-your-face sentence.

Let me show you the power of words:

"It's twins!"
"It's cancer."
"You're hired."
"You're fired."
"Will you marry me?"

Thinking these phrases doesn't do much. Even a sono-gram of two heartbeats can be confusing and a shiny ring in an open box can be perplexing if not accompanied by the matching, audible phrases.

The Bible says that the power of life and death are in the tongue—**the very words you *speak*.** I believe we just say that little proverb casually and don't soak it in.

Why couldn't David just think about God or just ponder about his rescuer? Because everyone and everything around him *spoke* the opposite. Goliath is big. You are not. This is dangerous. This problem is unconquerable. You are just a shepherd.

What's been spoken over you? What words are resonating in your soul about your situation? What are you saying about whatever you're facing? Are you speaking more about your Goliath or about your God?

The tongue can bring life.

The words you say can restore.

The phrases you proclaim can heal.

Take a moment today and mentally put yourself on speaker phone. Watch your words. Listen to see if what you're speaking matches up with God's promises. Stumble over what you almost said negatively about your situation and quickly replace those phrases with life from the Word of God. Align your words and your actions with your God and the goodness He wants for you.

"Death and life are in the power of the tongue." Or, rewording it, "The words you speak can lead to life or they can lead to death. You pick."

He said, she says

Over the next few chapters we'll look at personal giants and how to use the Sword of the Spirit—the Bible—to defeat those giants. The title of this book is "He Said, She Says," not "...she thinks." Let's remember our words matter. Let's pray aloud the very words of God. Let's say what He said:

Heavenly Father, I commit to, like David, know more about what You say about what I'm going through. I pray that You will guide me as I learn to be the conqueror You made me to be. Your Word says "Death and life are in the power of the tongue." Lord, let my words be life! Psalm 141:3 says, "Take control of what I say, O Lord, and guard my lips." That is my prayer. And I know You will answer because You promised in 1 John 5:15 that we will have what we ask of You. Thank you. In Jesus' name, Amen.

For personal devotion or small group study:

(Consider sharing your answers with others)

1. Write down something you're facing or perhaps something a friend is going through. Using the internet or a reference book, find a few Bible verses about what God says about this topic.

2. Rewrite these verses in your own words:

 Psalm 84:11

 Romans 8:28

3. Think about your conversations on what you wrote in question #1. Do your words align with the verses you wrote in question #2?

4. Why is it so difficult to align our words with THE Word?

5. Read these verses aloud, then write down what each means to you based on your current life situation:

Hebrews 4:12

Psalm 119:105

Isaiah 40:8

Luke 11:28

James 1:22

5

What He Said About Fear and Anxiety

***Disclaimer time**

Normally, I'd get right into a story here, but I want to begin with a disclaimer. I understand far too well the stigma behind the words fear, anxiety, depression, and all such synonyms. This chapter is not talking about a mental or clinical diagnosis (see Chapter 6 for that). And I know that you may not have fear or anxiety or worry or such synonyms as part of your life. But I do know two things: You are not immune to this giant and your friends are not immune to this giant. So, even if this chapter is not for you right now, it might be that you're reading it just for someone else who needs it. Galatians 6 tells us to carry each other's burdens. How awesome would it be for you to use this very chapter to lift a load from a friend who is so weighed down by life right now?

Bigfoot

WE LIVE IN south-central Oklahoma, an area known for, ahem, "Bigfoot Sightings." As of the writing of this book, no one in the world has ever captured and produced, for scientific study, a live or dead sasquatch. So these "sightings" are fun to imagine and make for some pretty great campfire stories, but that's all they are—stories. And I know that. I mean, no part of me believes in Bigfoot.

We had just returned from a touristy, forest town, famous for its sasquatch hunts. Every gas station and corner fruit stand had a variety of Bigfoot shirts, magnets, and stickers ready for purchase. We hadn't hunted, of course, but instead spent our time relaxing in a cabin, and me writing my first book.

Back at home, I sat on my couch, folding laundry and watching TV, when something moved in my peripheral vision. Right outside my living room window, something large and hairy and beastly moved from side to side, no doubt staring me down. With a lump in my throat and sudden belief—I knew it was Bigfoot.

Or maybe just the neighbor's crape myrtle bush.

Earthquakes

I've actually been in an earthquake right here in Oklahoma. One was around ten years ago and, even though the epicenter was fifty miles away, it shook our light fixtures and skewed pictures on the walls. I felt it under my feet and, even though not technically possible, over my head.

Thankfully, Oklahoma is not known for earthquakes, and damage from earthquakes is extremely rare.

In 2020, though, something "earthquakey" happened to all of us: a world-wide pandemic. I remained mentally unscathed for a while, but I clearly recall the night I just let my guard down and let it all get to me. And by "it" I mean the news and fear and social media political rants and arguments about masks and closed businesses and no school and a coughing fit with no cause and... well, you get the picture.

My mind was just swarming. I hadn't meant for it to happen. But, just like getting wrapped in a warm, wet blanket on a sweltering hot day, I was covered in smothering worry and fear.

Michael knew none of this. The day I let my spiritual guard down, he was still happily going through life and,

at the end of the same day, getting ready for bed. I tried to be cool and collected, but you know how those crazy thoughts can be. I brushed my teeth, said a few prayers, washed my face, then made my way to the bedside.

Just as I reached to pull back the sheets and hop in bed, the entire bedframe began to shake and buzzed a horrible, base-roaring sound. "Earthquake!" I shouted, completely *not* shocked that some other tragedy had made its way into my life.

That's when Michael calmly looked at me, bed remote in hand, and turned off the humming, gently vibrating box-spring feature that soothed and massaged sore back muscles. No earthquake—just (what was supposed to be) a relaxing option on our new mattress.

I'm not crazy

By now I've no doubt you think I'm crazy. Or perhaps you're just laughing at all my wild antics because, well, you've done something similar. I'll go for the latter.

There's this huge misconception that just because I minister and speak and write books and devotions that I've got it all together all of the time. Ha! Can I tell you that there is a verse that I live by? There is a verse that we

all should live by. Romans 12:2 says, "Be transformed by the renewal of your mind."

I'm under the strong impression that my teeth need to be renewed daily. Each day (usually twice a day), I'll renew, or brush, my teeth. Each day, I renew, or wash, my face. Each morning, I renew, or comb, my hair. Renewing our mind is a *daily* process. Sometimes it's a twice-a-day process. Hey, sometimes it's a minute-by-minute process. And not renewing our minds is just like me letting my guard down. It's like not cleaning my brain's filter with the Word and, instead, allowing the world to infiltrate.

Bigger than Bigfoot and stronger than an earthquake

I've spoken with ladies all around the US—ladies whose fears are more powerful than an imagined Bigfoot or a made-up earthquake. Fears that make sleep a thing of the past. Fears that are deep rooted from family situations or from recent crisis. Fears that—like Jonah's— could, humanly speaking, *come to pass.*

I've spoken with mamas who have lost their babies, with women who were hurt by an ex-husband, and with teenage girls who are tormented by words of former friends. Can I tell you something? Their fears stare

them in the face daily. Their fears have voices and raise weapons. Their fears rob them of the ability to do daily tasks and steal their joy and peace and sleep. Their fears debilitate and create sickness and cause confusion.

I don't know where you fit in. I don't know if fear is just a fleeting thought that humorously goes away like Bigfoot in the bushes or if fear is dictating your every move. The good news is, I don't have to know where you fit in, because the Word of God is one-size-fits-all. It is a weapon for your biggest battles and your smallest struggles. It's a weapon you can pick up at a moment's notice, right when you need it the most, even if you haven't used it in years.

He's no boo boo

Wouldn't it be great if life were all thornless roses? If we woke up singing songs and frolicking through the bedroom like Buddy-the-Elf chiming, "Isn't this a syrupy and wonderful morning?" While we, as adults, don't (normally) do that, we often try to sugarcoat life with children. Take for example a cut or bruise. Tommy the toddler could be gushing blood and we'd say, "Oh, you have a little boo boo." A full-blown tornado could be over

the horizon, but we'll tell scared Sally, "Oh, honey, it's just a little wind."

There's one place in life, however, where we as adults *do* gloss over the negative and pretend this statement is false: we have a spiritual enemy. As much as we don't want to talk about our spiritual enemy, God does. In His word, God shakes us and wakes us with a verse. Now, when you read it, I want you to read it like a football coach in the locker room at halftime, down by twenty-one points, trying to talk some sense into his team:

"Stay alert! Watch out for your great enemy, the devil. He prowls around like a roaring lion, looking for someone to devour." (See 1 Peter 5:8)

God doesn't sugarcoat the fact that the devil wants us to fail. The devil wants to devour us. Ephesians goes on to say that our battles aren't even mental or physical or relational—our battles are against spiritual forces.

Do you know what I have to say about that? *Perfect.* That's absolutely perfect because God gave me the exact weapon I need to win that battle! His Word is the sword of the Spirit and is the weapon mentioned in Ephesians that can and will defeat "evil spirits in the heavenly places."

Swing your sword

While we can, technically, pick up our spiritual weapon—the Bible—at any time and use it at a moment's notice, we might feel overwhelmed at all the "thou shalts" and version choices and "but that's not what grandma said" contradictions if we do. Consider this your "how-to class" for spiritual warfare. Consider this your lesson in daily renewing your mind, your tutorial for swinging your spiritual sword, and your training for battle. Consider this your "here's how to fight" moment.

What He says about Fear:

You know how most little kids pick their noses? Cole NEVER did. I mean never. If he saw another kid in kindergarten doing it, he'd start gagging. So, if we went to a friend's house for dinner, I never added "don't pick your nose" to a list of etiquette reminders. Sure, "don't pass gas" was in there, but never "don't pick your nose." Why? Because he wasn't prone to do it. It wasn't a part of who he was and is.

Just like I know the ins and outs of my son, God, too, knows the ins and outs of His children. Over and over

throughout His word, He gives us a list of reminders-turned-weapons about worry. He knew we'd be prone to fear, and here's what He said:

Proverbs 12:25
Worry weighs a person down…

2 Timothy 1:7
For God has not given us a spirit of fear and timidity, but of power, love, and self-discipline.

Isaiah 41:10
Don't be afraid, for I am with you. Don't be discouraged, for I am your God. I will strengthen you and help you. I will hold you up with my victorious right hand.

Philippians 4:6-7
Don't worry about anything; instead, pray about everything. Tell God what you need, and thank him for all he has done. Then you will experience God's peace, which exceeds anything we can understand. His peace will guard your hearts and minds as you live in Christ Jesus.

1 Peter 5:7
Give all your worries and cares to God, for he cares about you.

Philippians 4:8
Fix your thoughts on what is true, and honorable, and right, and pure, and lovely, and admirable. Think about things that are excellent and worthy of praise.

Romans 8:37
Overwhelming victory is ours through Christ, who loved us.

He said, she says: let's battle

If you didn't already, I encourage you to go back and read those verses *aloud*. Remember, the power of life and death is in the tongue—the spoken word. Let's pray these very words and, in doing so, fight and *win* this spiritual battle!

Heavenly Father, thank You for knowing me. Thank You for giving me these verses for this time

in my life. God, worry does weigh a person down! I feel so heavy at times, but I know that heaviness is not from You. I know that You want me to give You my worries. You gave me a spirit of power, love and self-discipline and not of fear and worry. Your Word says I don't need to be afraid or discouraged, because You are with me. You will strengthen me. Your Word says instead of worrying, I should pray about everything. I should tell You what I need and thank You for what You've done. Today I bring these concerns to You. (Let Him know what's on your heart). Father, I give them to You completely. I believe that because I've given them to You, I will experience God's peace which exceeds anything I can understand! I believe and confess that peace right now. I commit to thinking on good things, things that are right and pure and lovely and worthy of praise. I believe and proclaim that overwhelming victory is now mine through Christ Jesus. Thank You for winning this battle! In Jesus' name, Amen.

This prayer is full of the very words of God from scripture. It's a sharp, spiritual sword that wins every

battle. I encourage you to pray it often as you renew your mind. I encourage you to swing this sword daily. I pray you'll remember that because He said it, you can say it, and believe it!

For personal devotion or small group study:
(Consider sharing your answers with others)

1. Write down something that causes you (or a friend) worry, then rank it on a scale of one to ten, with one being "It's just a mild thought" to ten being "It consumes me, robs me of sleep, and sickens me."

Rank:

2. Write down one of the verses mentioned in this chapter that spoke to you and this issue. Rank it on a scale of eleven to twenty, with eleven being "Yes, I believe it" to twenty being "I am a conqueror and have won this battle!"

Rank:

3. Do you see that, on purpose, no matter what you ranked your fear in the first question, the Word of God always ranks higher! Ephesians 3:20 says God can do "infinitely more than we might ask or think." When it comes to living in fear, where have you been limiting God?

4. How often will you commit to praying this chapter's prayer (or a similar prayer)?

6

What He Said About
Mental and Physical Illness

I didn't sign up for this!

OUR FAMILY LOVES to vacation. The ocean, mountains, RVing, road trips, cruise ships—it doesn't matter! When Cole was around five, we made a trip to Orlando to hit all the theme parks. At that age, though, Cole didn't even care about rides. He was more interested in meeting as many cartoon characters as possible. And he was the perfect age. He told jokes to Donald and carried on a wild conversation with Goofy.

I'm not much of a ride person myself. I'll puke. TMI? I'm just being honest. But EPCOT (did you know that stands for Experimental Prototype Community of Tomorrow?) was great for all of us. With nice, slow rides and plenty of characters—not to mention great food—it quickly became one of our favorite parks. The best ride

for me was Spaceship Earth. Tucked in a wide spiral in the center of the iconic golf ball sphere, guests are transported calmly and gently through a story of time.

Fast forward a few years, and characters and slow rides were in Cole's past. He sought out all the tall, curvy, death-defying roller coasters at any theme park we visited. So, when we bought tickets to Disneyland in California, he couldn't wait to jump on the first thrill ride. For most rides, I stood in the shade, patiently holding bags and baseball hats and melting drinks, as father and son dared gravity.

That is—until we reached the sign for Space Mountain. *Wasn't this the ride from EPCOT? The slow, soft, gentle ride, gliding through a story of time?* I couldn't wait to board. As we approached the final turnstile, I had a strange feeling in my gut, though. Something just didn't feel right as I sat in my seat, firmly planted behind Michael and Cole, and buckled my seatbelt.

That's when it happened. The jet engine burst me into darkness and wind and flashing lights. Allow me to read from Disney's description of the ride:

As you hurtle forward into infinite darkness, your rocket darts and twists into the void, speeding faster and faster. Feel the g-force as you careen into the unknown!

Um... I did not sign up for this.

At first, I screamed. Over and over, louder and louder, as though a gigantic spider was crawling up my arm inching closer to my face, ready to inject deadly poison. Then, the screams came to a screeching halt as my stomach began to flip. I couldn't scream. Screaming would only provide an escape route for what was churning in my tummy.

Once back on the ground, I sat for a few hours, doped up on motion sickness pills and crazed adrenalin, all the while wondering how I could have confused Spaceship Earth with Space Mountain.

You didn't sign up for this

I don't know what you're going through or what you've been through or what test results you're waiting on or what sickness you're walking through with a family member or friend. But I do know this: You didn't sign up

for it. You didn't buy a ticket and stand in line to board the cancer coaster or the depression train or the caregiver cruise.

But here we are. Or will be. Or have been.

Simon Peter

We know quite a bit about Simon, normally called Peter, from the Bible. Peter was a great friend of Jesus. He knew Jesus. He loved Jesus. He believed in Jesus' healings and even saw them firsthand. But knowing, loving, and believing Jesus did not make Peter immune to life and its sickness and disease. In the book of Luke, we read that Peter's own mother-in-law was going through a tough time of sickness with a high fever. I wonder if Peter was concerned. I wonder if he rushed to her bedside and cried or wondered "what if?" What we *do* know is that Jesus was (and is) pro-healing. Jesus was ready to answer their prayers of "Please heal her" (Luke 4:38). And Jesus healed. The word says, "She got up at once" (verse 39, NLT).

Jairus

We don't know as much about Jairus. What we do know is that he was searching for Jesus. I'm not sure if Jesus was his first option for healing or his last, but Luke tells us Jairus "fell at Jesus' feet, pleading with him to come" and heal his young daughter who was dying (Luke 8:42, NLT). And Jesus went with him. While he was on his way, others approached Jesus for healing and ministry, and they were healed. I don't know if Jairus was praising that they were healed or completely jealous and enraged for the time they were taking away from his issue. I wonder if he rushed Jesus, grabbing his coat and crying, "Hurry!" What we do know is that someone came up to the both of them, saying something that would contradict Jesus and His power: "Your daughter is dead" (verse 49, NLT). I'm going to go out on a limb here and say that Jesus said this next statement with a calm confidence. I don't believe he yelled it or said it with anger or said it with fear. Jesus said directly to Jairus, "Don't be afraid. Just have faith, and she will be healed" (verse 50, NLT).

The People

In the same story, we see a group of people. We see people who doubted and who were grieving. Jesus tells them, "Stop the weeping! She isn't dead; she's only asleep" (verse 52, NLT). While we don't know much about the individual people, we do know they loved this family. We know they wanted good for them and were saddened at what they saw with their eyes. But we also know that they hadn't seen anything with their hearts. When Jesus said, "she isn't dead," none of them said, "Oh, good! Thanks, Jesus. We believe You have healed her even though she's still motionless in that bed." We see family and friends who didn't believe in Jesus' healing so much that they "laughed at him" (verse 53). Jesus did something very interesting here. He dismissed all those from the home who didn't truly believe. Only Peter, John, James, and the girl's parents remained. And once the unbelievers were silenced, Jesus commanded the child to get up—and she did!

You

We know quite a bit about you—or at least *you* know about you. I can assume from the fact that you're reading this book that you, like Peter, know Jesus. I can assume you love Jesus. I'm pretty sure you believe in Jesus' healing. But, also like Peter, knowing and loving and believing in Jesus doesn't make you immune to life and its sickness and disease. But you, like Peter, know about Jesus. You know He is pro-healing. You know…

> You may be in the world and its sickness and disease, but you are not of the world and do not belong to the world (see John 17:9-16).

> The One who lives within you is stronger than the world with its sickness and disease (see 1 John 4:4).

> Even though weapons may come against you in all forms, they will not prosper when your trust is in Jesus (see Isaiah 54:17).

The exact same spirit that raised Jesus from the dead lives within you (see Romans 8:11).

And, like Jairus, I'm assuming you have run to Jesus. I don't know if you've looked at others who received instant and visible healing and have been jealous. I don't know if you've asked, "why?" or pleaded, "hurry!" I don't know if someone has contradicted what the Word says in the verses above, telling you: "Your mental health won't change. Your cancer will return. Your spouse will never be healed. Your child will forever be sick." And, I picture Jesus saying to you, like he did to Jairus, "Don't be afraid. Just have faith, and ___ will be healed." Because Jesus is for you. Jesus is on your side. While we may not see the physical and visible signs of healing right now, we do know...

God is for you. (Romans 8:31)
Victory belongs to you. (Romans 8:37)
He wants good for you. (Psalm 84:11)

Like Jairus, you may have people. You may have people who love you and support you and cry with you, but they do not believe. They are only looking at what

they can see *physically*—not spiritually. They laugh when you pray or believe or confess. Their doubting, like pouring water on fire, is hindering and squelching your faith. Jesus said, "Just have faith, and ___ will be healed." If faith is the prerequisite, those who love you may not be helping you.

I don't know what it looks like for you to dismiss the words of those who don't believe and those *things* that counteract your faith. I'm not sure what mental decisions you must make. I'm not sure whose voice you must silence. I don't know what books you must put away, what social media platforms you need to uninstall, or what thoughts you need to destroy. But my prayer for you is that God will dismiss and block anything standing in the way of you and faith. Because once the unbelievers are silenced, once the doubt is gone, once your faith is firm—your miracle is on the way. (Hint—it's likely already there! You just can't *see* it yet.)

So, while I don't know exactly what or who is tainting your faith, I do know that God has a lot to say about the subject. (Why? Because *He wants you healed!*)

Jesus said to the disciples, "Have faith in God... You can pray for anything, and if you believe that

you've received it, it will be yours." (Mark 11:22 & 24, NLT)

It is impossible to please God without faith. (Hebrews 11:6, NLT)

Trust in the Lord with all your heart; do not depend on your own understanding. (Proverbs 3:5, NLT)

Faith comes from hearing, that is, hearing the Good News about Christ (Romans 10:17, NLT)

For we live by faith, not sight. (2 Corinthians 5:7, NIV)

We destroy every proud obstacle that keeps people from knowing God. We capture their rebellious thoughts and teach them to obey Christ. (2 Corinthians 10:5, NLT)

Fix your thoughts on what is true… and right. (Philippians 4:8, NLT)

But I still feel (insert negative word here)

By this point in the book, we're all real, raw, and authentic. I get it. I know you might feel ___. At this very moment while my fingers are clicking letters on the keyboard, the doctors and tests and scans have told my aunt she has cancer. Just yesterday I saw a Christian counselor to talk me through issues with stress and grief. A friend's baby is in the hospital, born so early she weighs less than a pineapple. Another friend's mom is in the hospital with a broken leg. Still another friend is facing a clinical diagnosis of anxiety and depression. I'm not saying we walk around, pretending negativity doesn't exist. I'm saying we become Elijahs.

Elijah

Elijah didn't ignore the drought. 1 Kings 18 tell us this dry spell had gone on so long that it had been three years since signs of a good rain. Food was scarce. Water was likely contaminated. Famine was severe. King Ahab even searched "every spring and valley in the land to see if we can find enough grass to save at least some of my horses and mules" (1 Kings 18:5, NLT). Elijah was right

in the thick of this, but he was a servant of God, full of faith and known for that faith.

I want to share the Word with you first, then we'll hash it out:

Then Elijah said to Ahab, "Go and get something to eat and drink, for I hear a mighty rainstorm coming!"… Elijah climbed to the top of Mount Carmel and bowed low to the ground and prayed. Then he said to his servant, "Go and look out toward the sea." The servant went and looked, then returned to Elijah and said, "I didn't see anything." Seven times Elijah told him to go and look. Finally the seventh time, his servant told him, "I saw a little cloud about the size of a man's hand rising from the sea." Then Elijah shouted, "Hurry to Ahab and tell him, 'Climb into your chariot and go back home. If you don't hurry, the rain will stop you!'" And soon the sky was black with clouds. A heavy wind brought a terrific rainstorm. (1 Kings 18:41-45, NLT)

Before he saw evidence and *before he even prayed,* Elijah prophesied the promises. He said, "I hear not just

sprinkles, but a mighty rainstorm!" Even when there wasn't a cloud in the sky, Elijah didn't doubt. Even on the second time they looked for rain, the third, the fourth, the fifth, the sixth... *nothing*. Elijah didn't give up or give in. And that seventh time, he saw something with more than just faith. He saw something with his eyes. He didn't see thunderclouds growing in the distance. He didn't even feel drops of fresh rain falling on his face. He saw a tiny cloud, the size of a hand, just over the horizon. The answer.

Before you see evidence, before you even pray, prophesy the promises in the verses above. Speak them. If faith comes by hearing, then talk to yourself over and over with His precious promises. Don't give up. Keep looking. Even when you see nothing. Keep looking. Even on the second time you pray and proclaim, the third, the fourth, the fifth, the sixth... don't give up or give in. And when you see that glimmer of hope, shout His praises. His will is healing! His desire is joy! His Word is for you. Now, let's say it.

He said, she says: let's battle

If you didn't already, I encourage you to go back and read those verses *aloud*. Remember, the power of life and death is in the tongue—the spoken word. Let's pray these very words and, in doing so, fight and *win* this spiritual battle!

Heavenly Father,
You know me and You know what I'm facing. Your word says that even though this weapon may be formed against me, it will not prosper. I may be in this world and face this issue, but I belong to You, and You are greater! Your Word says the exact same spirit and power that raised Jesus from the dead lives in me. I know You are for me, want good for me, and victory belongs to me. Father, I know that I must have faith. If I do, Your Word tells me I can pray for anything, believe that I've received it, and it will be mine. Today, I pray for (let Him know your needs and requests). Father, I commit to trust You in this and not my own understanding. I commit to fixing my thoughts on what is true and right. And, I KNOW what is true and right—You

are my healer! I believe and confess and proclaim health and healing. In Jesus' name, Amen.

For personal devotion or small group study:
(Consider spending time sharing your answers with others)

1. What's your gut reaction when you hear that God knows you?

2. What verse from this chapter can you memorize for those times when something comes to rob your faith?

3. Imagine your life free of whatever issue you're facing. How would you feel? What would be your emotion? Now, like Elijah prophesying the promise of rain before he even saw a cloud, praise God for bringing this issue to a resolution!

7

What He Said About
Insecurity and Guilt

Frizzy Hair/Don't Care

ALLOW ME A moment to describe someone for you. She's eleven years old, maybe twelve. Her braces are the chunky metal kind with tiny colorful bands around each bracket. She picked a red, white, and blue theme so that her smile would celebrate the upcoming Independence Day. Her thick-rimmed glasses are apple red and prevent her from being legally blind. She can't walk very straight, so the doctors just fitted her with custom plastic inserts for her penny loafers. She laughingly calls them milk jug inserts. Her face is covered with foundation to hide her bumpy pimples. Her hair is freshly permed, but without any gel or mousse, so the frizz is out of control. The big hair matches her big bangs, piled high on her forehead, but not higher than her big red bow.

Me.

The odd part here (oh, there are many odd parts) is that I thought I looked good. I rocked those glasses. I showed off my braces. I put the biggest bow in my spirally hair. I tucked the shiniest penny into those loafers. (Some of you are having to Google penny loafers right now.) I smiled so big in my school pictures that you almost didn't notice my crocheted sweater vest not matching my grape purple shirt. Almost.

What happened to that girl? Where did that confidence go?

Gravity

My age seven backyard was large enough for a tire swing, playhouse, my daddy's workshop, and the best part of all—an old, metal, A-frame swing set. I have vivid memories of burning my legs on that hot, tin slide and of duct-taping plastic on the broken see-saw seat. But one memory stands out more than others: the day I attempted to fly.

I had it all planned out. One Sunday afternoon, right after church, I ditched my frilly dress for a T-shirt and shorts and headed to the swings. The half rubber, half plastic seat molded itself around my tiny backside as I

sat down and wiggled into position. I reached to grab the chains holding the swing and my forty-pound self (I was super tiny as a kid). I began to pump. Legs in, legs out, higher and higher. Feet to the sky, feet tucked under, over and over. *This was it*, I remember thinking. *If I can let go and jump at just the right time and flap my wings, er, I mean arms, surely I'll fly!*

I was so high in the air that the metal posts of that A-frame swing set were lifting from the ground. Right when I knew I couldn't get any higher without flipping over, I let go, jumped, and flapped, and...

Gravity.

Guilt and Insecurity

There's a good chance in life that you've been a version of an age eleven or seven me. Perhaps you've been confident in who you were as a mother or maybe secure in the fact that you're *not* a mother. You've been content with your position at work or in school, and you've been pleased with your size or weight or relationships or mental state. And then something changes. Perhaps you've scrolled through social media, looking at images of overly perfect women with overly filtered families. Maybe you've been

questioned with "why aren't you married?" or "when will you have kids" or "why didn't you graduate" so often that you're questioning your once-confident self. You're no longer secure. You're now covered in guilt, not living up to new and confusing standards.

Perhaps you had plans of flying high spiritually, mentally, or physically. You put lots of effort into Bible studies, meditating on the Word, and self-discipline. You pumped higher and higher, with everything pointing in the right direction. Surely this would be the time when you became confident in who God created you to be and in the purpose He has for you then the gravity of comparison and not living up to next-door-Nancy tosses you down.

Insecurity and guilt go hand in hand. How often do we compare ourselves to others or to unrealistic standards so much that our confidence crashes? Then, guilt sets in because we aren't who we think we should be or who we think others want us to be. It's been said that comparison is the thief of joy. I'll take that a step further. If comparison is the thief of joy, then insecurity is the assassin of purpose.

God has a purpose for you, and it is good and it is *yours*. It's not your sister's. It's not your neighbor's. It's not

the same purpose as the dance mom from your daughter's afternoon class and it's not the same purpose as your recently promoted boss. God's purpose for you is unique and it's yours—only yours.

Did you know God created you for good things? The latter part of Ephesians 2:10 says that not only are you God's masterpiece, but that your God-given purpose in life is to "do the good things he planned for us long ago" (NLT).

God created you to do good for your children. You, sweet mama, are the exact woman God picked to parent those sweet babies! He will equip you and give you talents and skills and wisdom when you ask. Guess what? God didn't pick I-baked-fresh-chocolate-brownies Brittney to be their mother. He didn't equip her and give her the talents and skills to do the good things that He planned for *you*.

God created you to do good for your friends. You, sweet sister, are the exact woman God picked to be in their lives. He will equip you and give you the words to say and the encouragement to provide. God gave you the skills and talents you need for the work you do each day. No matter if it's in an office or at a school or reading bedtime stories over and over in the middle of

the day—God created *you* and gave *you* talents and gave *you* skills and gave *you* purpose so *you* can do the good that He planned for *you*.

It's time we stop the guilt of not living up to ungodly expectations, and it's time we get rid of being insecure in who God created us to be so that we can live—free and bold and confident.

David

In the book of 1 Samuel, we see David. You might remember that David was the youngest of his brothers. Often overlooked and discarded as "just a shepherd boy," David could have easily lost any confidence and succumbed to the guilt of not living up to others' expectations. You might recall that, while his older brothers fought on the battlefield, David stayed home in the fields until one day when his father said, "Take this basket of roasted grain and these ten loaves of bread, and carry them quickly to your brothers" (Chapter 17, verse 17, NLT).

Let's just stop right here. Remember that eleven-year-old, dorky and nerdy me? At some point around age thirteen, my confidence went right out the window

and a mixture of awkwardness and self-consciousness set in. I felt clumsy and stared at and judged and insecure all at the same time. David's dad asking him to take bread to his older brothers on the battlefield is the equivalent of my mother asking age thirteen, dorky me to take a basket of cookies to the high school cheerleaders in the middle of their practice.

Are you squirming?

Apparently David wasn't, because the story says that David, without hesitation, went. I picture David walking tall, taking in all the sights and sounds of the Israelite camp. That's when David heard the enemy, Goliath, shouting taunts and threats to the Israelite army. David, still unphased that he was "just a shepherd" surrounded by warriors, asked, "Who is this pagan Philistine anyway, that he is allowed to defy the armies of the living God?" (v 26, NLT).

Well, this sent David's brothers into full-blown let's-take-away-David's-confidence mode. David's oldest brother, Eliab angrily said, "What are you doing around here anyway? What about those *few* sheep you're supposed to be taking care of? I know about your pride and deceit. You just want to see the battle!" (v 28, NLT) David went to Saul, the king, boldly offering to fight Goliath. Saul's

response? "Don't be ridiculous! You're only a boy!" (v 33, NLT).

Let's talk about what David did not do. David didn't say, "Wow, I *am* just a shepherd boy. I *am* young. I don't feel prideful, but Eliab thinks I am. Am I? *What am I doing here?* I don't belong…"

Do you know what David did? David told anyone and everyone who would listen about the God who equipped him for battle. He told them about the God who saved him from the lion and bear in the sheep pasture. He told them about the God who gave him the characteristics of a young man who cared for his father's animals and protected them from death. David didn't even acknowledge Eliab's jabs or Saul's rebukes. David simply said, "I'll go fight!"

And David did. And David won.

Cowboy boots

Let's pretend for a moment. Let's pretend you just bought tickets to a large women's conference where I'm a guest speaker. You and your group of friends enter the stadium wearing matching shirts that say, "He said, She says" in yellow cursive print on a cottony pink

background. You even go so far as to wear matching white sneakers with neon green socks. You figure, if you're going to make a fashion statement, it should end with an exclamation point!

I'm right in the middle of my message when I notice you from the stage. I call you up to stand next to me. Everyone cheers and can't wait to see what will happen next. That's when I notice your shoes. I turn to you and say, "Wow! Those are the nicest cowboy boots I've ever seen! Did you buy those in Dallas, because, wow, they look expensive! Are they made from alligator? The deep reddish-brown color is just so perfect."

What would you think? Would you ever look at your white sneakers and wonder, "Hmmm… *are* these boots? I mean, Allyson is the speaker so *surely* she knows what she's doing? Maybe these are really cowboy boots?"

No. You would think I was nuts. You'd never once believe that your shiny white sneakers with neon socks were actually boots. You'd be completely, 100 percent confident in your shoes.

That's how much confidence you need to have in the masterpiece that God created—that is you. No matter what others say or think, you need to know He's equipped you and prepared you and given you talents

and characteristics and skills to do the good things He created you to do.

He said, she says: now what?

I don't know about you, but I've got to do a little repenting here, asking God to forgive me for feeling guilty that I'm not like someone else and for being insecure in who He created me to be. I need to talk with God about using my talents and skills for good instead of comparing them to my sweet sister's down the street. I need to thank Him for creating me as a masterpiece and ask Him to open my eyes to the beautiful soul He designed me to be. Will you join me?

Heavenly Father,
I'm sorry. I'm sorry for the unnecessary guilt I feel
from comparing myself to another one of Your chil-
dren. I'm sorry for being insecure in my talents and
skills and personality traits. You made me for good
works. You made me for You! Thank You! I ask
that You show me times and ways I can do good for
others. I pray you will increase my confidence and

equip me even more! I love You, my Creator and heavenly Father. In Jesus' name, Amen.

For personal devotion or small group study:
(Consider spending time sharing your answers with others)

1. How have you struggled with insecurity or guilt?

2. Read John 10:10. In what ways have insecurity, guilt, or comparison tried to steal your joyful life?

3. Read these verses aloud:

 Psalm 139:14

 Ephesians 2:10

1 Peter 4:10

4. From those same verses, create "I am" statements.

"According to the Bible, I am…

8

What He Said About Loneliness

Alone and Lonely

ISN'T IT AMAZING that the words *alone* and *lonely* are so similar, yet you can be the opposite of alone, yet still lonely? You can be in a room full of people, a church with filled pews, a party with talkative and laughing ladies, but still feel alone.

This is the chapter for those of you (us) who have ever felt like you (we) didn't belong. This is the chapter for those times when something feels missing. This is the chapter for the widow and the woman recently divorced and the woman without children, and it's equally the chapter for the woman in a loveless marriage, surrounded by children who rarely leave their rooms. This is the chapter for the woman who has felt like an outcast for five minutes or five years. This chapter, my sweet sister, is for us.

Puzzles

I hate—*detest*—puzzles. Yet I found myself forcing myself to open the thin cardboard box, remove the lid, and dig for the corner pieces of the 1000-piece puzzle I dumped on my kitchen table. With a little extra time on my hands over vacation, I decided to do something that would purposefully slow my racing mind, something opposite of what I would normally do. This puzzle, surely, would do the trick.

Every puzzle has a theme, and this one was '60s nostalgia. Might I mention that I wasn't born in the '60s, so I'm just not sure why that box top caught my attention, other than the bright colors and detailed graphics which might lend themselves to making the puzzle completion easier and quicker.

I found the corners and filled in the edges. It took a few days but I managed to connect The Beatles to Chatty Cathy and the '69 Camaro to the gelatin mold. It was time to place the last piece when I realized… I was out of pieces. No matter how colorful and nearly perfect this picture staring back at me was, it had a hole. Not finished. Not perfect. Not complete.

I looked under the table. I scoured the chair cushions. I even carefully lifted the delicate puzzle to see if a piece had snuck underneath. Nothing.

Drowning

Our first trip to Orlando (the one where Cole talked to Goofy) was filled with great memories. It was a real, family vacation with my mom and dad (Cole's Meemee and Yogi) tagging along. We stayed at a beautiful resort where we could all be together, with adjoining rooms, a kitchen, and large living room. The hotel pool was breathtaking. Its zero entry edge meant we could walk straight in, as though walking from a sandy beach. The best part? A long, winding slide built into a rocky cliff, emptying into the pool below.

My dad, er, I mean Yogi decided to help Cole get over his fear of the slide. After a brief "Watch me" lecture, he climbed the steps of the cliff. Waving from the top, he then sat down and whooshed himself down the curvy slide. At some point, though, between the whoosh and the end, he remembered he wasn't a great swimmer—at all. That's when it happened.

Yogi began his ungraceful, flailing movements. Hands frantic, arms flapping about, and gravity taking over, he slipped closer and closer to the pool of water below. Splash! From the deck, all we could see was the panicked and berserk splashing that can only be made by someone drowning and clinging to the oxygen above the waves.

Yet no one tried to save him. No whistles shrieked from on-duty lifeguards. No brave souls rushed to his aid. No pointing from little kids yelling, "Mommy! That man is drowning!"

Why? Because... wait for it... *he wasn't drowning.* My dad, Yogi himself, was in three feet of water. All he needed to do was stand.

So... I take it back. DON'T be an Elijah

Remember the awesome, faith-filled Elijah from 1 Kings 18? The one who prophesied rain before there was a cloud in the sky? Just one, teeny, tiny chapter later, Elijah has a moment. One of those "I'm-all-alone, life-is-over" moments. In just a few short verses, things started looking bleak for Elijah. While the king may have been thankful for the rain, the queen was anything but! In fact, she was so upset with Elijah and his God-given power

that she threatened to murder him. 1 Kings 19:3 says, "Elijah was afraid and fled for his life" (NLT). He began a pity party of one, even asking his friend and helper to leave him. He was alone, lonely, scared, and confused. Verse 4 says, "He went on alone into the wilderness, traveling all day. He sat down under a solitary broom tree and prayed…"

Let me just stop there. Elijah the Great didn't pray for protection. Elijah the Faith Warrior didn't pray for comfort. No, the verse says Elijah "prayed that he might die. 'I have had enough, Lord,' he said. 'Take my life.'"

I'll summarize the next few verses, but, basically, the Lord doesn't answer that prayer the way Elijah asked. Instead, the all-knowing God of heaven strengthened Elijah, provided him food and drink and shelter, then sent him on a mission.

Why splash when you can stand?

Maybe you're all too familiar with Elijah. You've been rejected. Perhaps you've been scared or confused or fearful. And, not only are you alone, but you've been so deep into loneliness that you've even sent away those

who are physically close to you, trying to help. Life didn't or doesn't seem worth living.

Maybe you've got it all together... *almost*. Perhaps you're like that puzzle. From afar, you can see the picture clearly. Everyone thinks your life is bright and colorful and complete, but you know something or someone is missing, and you just can't stop thinking about it. You feel empty sometimes or all the time.

Can I tell you something? Even though the loneliness feels overwhelming, even though the emptiness is so consuming it's as though you're gasping for air under the water, you're not drowning. You need only to stand.

Stand on His promises. Psalm 147:3 tells us that God heals the brokenhearted and bandages their wounds. No matter what hurt you've faced and no matter who or what you've lost, God is right there. He's not there to condemn you for your tears, but to wipe them away. Stand on that.

Stand on His promises. Romans 8 tells us that Jesus loves us so much that nothing we can do can separate us from that love. No matter what love we've lost or never even experienced, God is love. And His love is more powerful than anything, any person, any emotion. In fact, "no power in the sky above or earth below—indeed, nothing in all creation will ever be able to separate us

from the love of God that is revealed in Christ Jesus our Lord" (Romans 8:39, NLT).

Stand on His promises. Hebrews 13 reminds us that God will never leave us. Ever. No matter how lonely we feel, He is right there, just waiting for us. God is saying to you, sweet sister who is surrounded by friends yet feels empty inside, "Stand." God is saying to you, sweet friend who is living your days and nights alone, "Stand."

Be on guard. Stand firm in the faith. Be courageous. Be strong. (1 Corinthians 16:13, NLT)

Put on every piece of God's armor so you will be able to resist the enemy in the time of evil. Then after the battle, you will be standing firm. (Ephesians 6:13, NLT)

Stand firm against [the devil], and be strong in your faith. (1 Peter 5:9, NLT)

Why splash when you can stand?

He said, she says: what Jesus *didn't* say

Something beautiful happens in the nineteenth chapter of John. Mary, the mother of Jesus, stood watching her Son as He was nailed to a cross. She watched as He was tortured and mocked. She watched, knowing she would soon have a missing piece in her life. And that's when Jesus did something beautiful. He didn't yell at her, saying, "Woman! You KNOW this is a part of God's plan! Death happens! Get over it!" He didn't look down on her and yell, "Stop your tears! You'll be fine, for crying out loud!" No, our precious and loving Jesus looked at his mother as she stood next to His disciple John and said, "Dear woman, here is your son," and in that moment, He let her know that she was not alone by placing John in her life.

And in this moment, He's done the same for you. No matter if you literally are alone or just feel like you don't belong, He wants to turn your loneliness into a loving relationship with Him. Don't push Him away. You always belong with and to Him. Let's pray.

Heavenly Father,

I feel (tell Him how you feel. Pour out your heart to your loving Father). But I know that You promise to heal my brokenness. You love me. I know You will never leave me. I know nothing can separate me from Your love. I choose to stand. I choose not to push You away, but to build a relationship with You. I choose to know You are near, to know You will not abandon me, to know with You I am not lonely. I choose to believe that You chose me. I love You and thank You for loving me. I pray that my broken heart will heal quickly as I accept Your love and Your friendship and a true relationship with You. In Jesus' name, Amen.

For personal devotion or small group study:
(Consider spending time sharing your answers with others)

1. Have you ever felt lonely or know of a friend who has?

2. After reading this chapter, what can you tell her/you about loneliness?

3. What words describe you when you feel lonely? (For example: sad, confused, hurt, etc.)

4. What does the Bible say about those emotions? Use the Internet or a reference book to search.

9

He Said, She Says

Right now

AS I'M WRITING this final chapter, I've been amazed at
how many women have confided in me about life issues.
Sandra cried as she sat in a chair across from me a few
days back and told of struggles with insecurities in her
relationships. Mandy just confessed to cheating on her
husband and is facing guilt and loneliness—physically
and emotionally. Bailey, recently diagnosed with a thyroid
condition, faces each day with pain and stress. Vanessa
can't seem to take much more, with needy toddlers and a
demanding stay-at-home job piled on top of her anxiety
and depression disorders. And Nicole battles misconcep-
tions and confusion, often wondering if her words will
ever be louder than her racing and destructive thoughts.

While I've changed names and scenarios above to
protect these sweet friends, I'll give you a clue as to the
identity of the last woman, Nicole. She's the little girl who

jumped from swings. She's the one with the frizzy hair and thick, red glasses. She's the college freshman who "accidentally" invited an ex on a date. She's the mom who threatened to murder her kid (not really). She's the one writing this book right now. She's the one who needs the words of this very chapter.

Let's face it. You, too, might be me or Sandra or Mandy or Bailey or Vanessa. You might be battling physically or you might be struggling emotionally. You might read this book and feel empowered, then five minutes later have a case of Meemze-inspired, spiritual amnesia, completely forgetting how to swing your spiritual sword. You might feel equipped after Chapter 5 or feel encouraged after Chapter 7, then the gravity of a swing-set jump crashes you to the ground.

Things I hate

Velvet. I detest velvet. Velvet hair scrunchies, velvet couches, velvet little-girl dresses. I know that "hate" is a very harsh word, but I mean it completely and totally with all the emotion intended. I also hate pickles and sad movies and my own handwriting. I hate when things rattle in the car and have been known to bring a road

trip to a screeching halt until the front and back seats have been ransacked to find and silence the noise maker (usually just a clicking zipper on a suitcase or a water bottle rolling around). One other thing that I hate is an unresolved story. A cliffhanger. That moment when you're about to find out if Harry really did fall in love with Sally only to have the movie interrupted by a power glitch. The feeling when you know the next page will reveal the killer in your true crime novel, only to realize that page has been ripped out.

Thou shalt not have cliffhangers. God doesn't. God flat-out, without holding back, tells you how to fight your battles. He tells you what to do when swing-set gravity brings you down in a resounding crash. His Word equips you, Sandra and Mandy, with lessons on how to conquer what you're facing. He's given verses to you, Bailey and Vanessa, on how to live victorious and how to feel released. He's told us all how to be an overcomer.

There's a beautiful verse in Revelation 12:11 (NIV) about the ultimate defeat of our enemy, Satan.

They triumphed over him by the blood of the Lamb and the word of their testimony.

Did you read that? We overcome battles and giants and depression and anxiety and sickness and guilt and insecurity and loneliness and misconceptions by the wonderful salvation we receive when we believe in and confess the death and resurrection of our Jesus and *by the word of our testimony*. By. Our. *Words*.

By testifying, proclaiming, and saying, like David did about his God and his giant,

> *I may have a battle ahead, but 1 John 4:4 says I belong to God. I have already received the victory because the Spirit inside me is greater than the spirit in this world! This is my testimony!*

By testifying, proclaiming, and saying, with faith like Elijah with the tiniest rain cloud,

> *I may not see the answer. I may not feel the answer. But I know God said He is for me and not against me and that I am more than a conquer, so I will overcome!*

By testifying, proclaiming, and saying, like a sweet widow suddenly empowered by 2 Corinthians 10,

My eyes and thoughts may tell me winning this war is impossible, but I have been equipped by God to destroy any thought that is against His perfect will for me.

By testifying, proclaiming, and saying, like the teenage girl newly equipped and committed to speaking God's word,

I know the words I say can bring life or death. So today, I will speak life and healing and encouragement and peace and only good things to and over this situation.

What is *your* testimony? What verse from the Sword of the Spirit do you need to hurl at your giant? What has He said in His Word that *you* need to say?

He said, she says: Topical Prayer Guide

Y'all, I LOVED my Student Bible when I was a teenager. Why? Just like my Algebra II book had all the answers in the back, my Student Bible did as well. I could look up "joy" and find verses about joy and happiness. I could

search the word "parents" and find it nestled between "panic" and "perseverance" and find "dating" tucked between "dancing" and "desire" (how appropriate).

So here's your "back of the book" prayer guide. Each prayer follows Philippians 4's pattern of

Rejoice in the Lord always. I will say it again: Rejoice! Let your gentleness be evident to all. The Lord is near. Do not be anxious about anything, but in every situation, by prayer and petition, with thanksgiving, present your requests to God. And the peace of God, which transcends all understanding, will guard your hearts and your minds in Christ Jesus. (Philippians 4:4-7, NLT)

and Romans 12's promise of

Let God transform you into a new person by changing the way you think. Then you will learn to know God's will for you, which is good and pleasing and perfect. (Romans 12:2)

and proclaims Jesus' promise of God's authority within us that

Anyone who believes in me [Jesus] will do the same works I have done, and even greater works, because I am going to be with the Father. You can ask for anything in my name, and I will do it, so that the Son can bring glory to the Father. Yes, ask me for anything in my name, and I will do it! (John 14:12-14, NLT)

So let's fight together! Let's hold up our swords while rejoicing, proclaiming, and petitioning with all the God-given authority we now know we have! Let's say what He said…

• • •

What He said…

Consider **empowering** yourself and others by saying, "I believe…" before reading each verse:

- The Lord will withhold no good thing from those who do what is right.
 (Psalm 84:11)

- [God] has given us great and precious promises.
 (2 Peter 1:4)

- God causes everything to work together for the good of those who love God and are called according to His purpose for them.
 (Romans 8:28)

- The Word of God is alive and powerful.
 (Hebrews 4:12)

- [The word of God] is a lamp to guide my feet and a light for my path.
 (Psalm 119:105)

- The tongue can bring death or life.
 (Proverbs 18:21)

- Even more blessed are all who hear the word of God and put it into practice.
 (Luke 11:28)

- We are human, but we don't wage war as humans do. We use God's mighty weapons, not worldly weapons, to knock down the strongholds of human reasoning and to destroy false arguments. We destroy every proud obstacle that keeps people

from knowing God. We capture their rebellious thoughts and teach them to obey Christ. (2 Corinthians 10:3-5)

Consider **equipping** yourself and others by saying, "I will…" before reading each verse:

- Be strong in the Lord and in his mighty power. [I will] put on all of God's armor so that [I] will be able to stand firm against all strategies of the devil. For we are not fighting against flesh-and-blood enemies, but against evil rulers and authorities of the unseen world, against mighty powers in this dark world, and against evil spirits in the heavenly places. Therefore, [I will] put on every piece of God's armor so [I] will be able to resist the enemy in the time of evil. Then after the battle [I] will still be standing firm. … [I will] take the sword of the Spirit, which is the word of God. (Ephesians 6:10-17)

- Give all [my] worries and cares to God, for He cares about [me]. (1 Peter 5:7)

- [Not] worry about anything; instead, pray about everything. Tell God what [I] need, and thank Him for all He has done.
 (Philippians 4:6)

- Fix [my] thoughts on what is true, and honorable, and right, and pure, and lovely, and admirable.
 (Philippians 4:8)

- Trust in the Lord with all [my] heart and not depend on [my] own understanding. [I will] seek His will in all [I] do and He will show [me] which path to take.
 (Proverbs 3:5-6)

Consider **encouraging** yourself and others by saying, "When I go through a battle, I will remember and proclaim…" before reading each verse:

- Jesus said… "you can pray for anything, and if you believe that you've received it, it will be yours."
 (Mark 11:24)

- I can do everything through Christ who gives me strength.
 (Philippians 4:13)

- [I] am God's masterpiece. He has created [me] anew in Christ Jesus, so [I] can do the good things He planned for [me] long ago.
 (Ephesians 2:10)

- God has not given [me] a spirit of fear and timidity, but of power, love, and self-discipline.
 (2 Timothy 1:7)

- [God says] Don't be afraid, for I am with you. Don't be discouraged, for I am your God. I will strengthen you and help you. I will hold you up with my victorious right hand.
 (Isaiah 41:10)

- He heals the brokenhearted and bandages their wounds.
 (Psalm 147:3)

- The Spirit who lives in [me] is greater than the spirit who lives in the world.
 (1 John 4:4)

- If God is for us, who can be against us?
 (Romans 8:31)

- The thief's purpose is to steal and kill and destroy. [God's] purpose is to give them a rich and satisfying life.
 (John 10:10)

- No power in the sky above or in the earth below—indeed, nothing in all creation will ever be able to separate us from the Love of God that is revealed in Christ Jesus our Lord.
 (Romans 8:39)

- Overwhelming victory is [mine] through Christ, who loved us.
 (Romans 8:37)

· · ·

She says...

Consider highlighting words within each prayer that mean something to you for the battles you're facing right now:

Heavenly Father, I rejoice that Your promises are for me. Every word in the Bible is alive and powerful, and I rejoice that every word is for me. Father, I am facing confusion. I'm struggling with understanding situations. But You said You will guide me and give me direction. As I read the Bible, I pray You will give me wisdom and clarity. You said when I put what I read into practice, I will be blessed. I receive those blessings! Thank You for that. In Jesus' name, Amen.

Heavenly Father, I rejoice that You want me to have a rich and satisfying life full of joy. Father, I feel discouraged. I'm sometimes afraid. But Your Word promises that You will strengthen me and help me. Your word says You are for me. Thank You! When the enemy comes to steal and kill and destroy my peace and confidence, I choose to trust

in Your promises of victory! Thank You for that. I speak strength and peace and victory over my life. In Jesus' name, Amen.

Heavenly Father, I rejoice that You are the God of the impossible. What I'm facing right now seems impossible! But You said I can pray for anything and, if I believe, I will receive it. You said overwhelming victory is mine. You said You are for me and on my side. Thank You! Today, I will give my worries and cares to You, because You care for me. Thank You for loving me. I speak victory over my life right now. In Jesus' name, Amen.

Heavenly Father, I rejoice that You cause everything to work together for the good for me. Your word says it. You said I shouldn't worry about what I'm going through, but, instead, should tell You what I need. Father, I need [be honest with your loving Father]. I thank you for all You've done. From this point forward, I will trust in You with all my heart. I will put You first and know You've promised that when I do, You will show me the way to go. I speak

good and godly direction over my life. Thank You for that. In Jesus' name, Amen.

Heavenly Father, I rejoice that You love me. Today, I am brokenhearted. I am sad. I am down. I'm facing emotional battles. But You said You heal the brokenhearted and bandage their wounds. Oh, Father, thank you for that! I receive Your healing today. I speak healing and comfort and joy over my life. In Jesus' name, Amen.

Heavenly Father, thank You for listening to me. I am scared. I'm fearful. But I know from the Bible that You did not put those feelings in me. You have given me a spirit of power, love, and self-discipline. Today, I will fix my thoughts on what is true, honorable, right, pure, lovely, and admirable. I will capture anxious thoughts and, instead, focus on You and Your Word. Thank You for the peace You give. I speak peace and power and love over my life. In Jesus' name, Amen.

Heavenly Father, I rejoice that You say I have victory. Today, I need victory over my health. [Be

open with God and let Him know what's on your mind.] But, no matter what, I believe that over-whelming victory is mine through Christ Jesus. I believe that greater is the Spirit within me than this issue in my body. I believe that even though the enemy is trying to steal and kill and destroy, You want me to have a rich and satisfying life. Thank you for that. I speak victory and health and joy over my life. In Jesus' name, Amen.

Heavenly Father, I rejoice that You have plans for me. Today, I need to feel that. I need to feel like I matter and that I have worth. I commit to believing that I am Your masterpiece and You created me to do good works. Father, show me how I can matter to others today. I speak confidence in who You created me to be. In Jesus' name, Amen.

Heavenly Father, I rejoice that nothing can separate me from Your love. No matter how lonely I feel, You will never leave me. You are on my side. You want joy and good for me. Thank You for that. I speak Your love and joy and goodness over my life. In Jesus' name, Amen.

Heavenly Father, I rejoice that Your word is for me and is true. Today, I'm facing situations where I need strength. [Open your heart to Him and let Him know what's on your mind.] But I know that You have given me strength. You have given me victory. You've promised and I believe it. Help me to receive what You have for me. I speak strength and victory over my life. In Jesus' name, Amen.

Heavenly Father, I rejoice that You gave me the ability to control my racing thoughts. Father, those thoughts seem overwhelming, but I know that overwhelming victory is mine. I know that You gave me the authority to fix my thoughts on You. You said when I pray about everything, tell You what I need, and thank You for what You've done, You will give me peace that will guard my heart and mind. Thank You for guarding my heart and mind! In Jesus' name, Amen.

Heavenly Father, I rejoice that You have given me great and precious promises. I rejoice that You will withhold no good thing from me. You said it, and I believe it. You cause everything to work together for

my good. Your Words are for me and are powerful. Your words guide me. When I speak them, I speak life. When I practice them, I am blessed. Thank you for giving me this spiritual weapon to battle all the wars and struggles that may come my way. Today I will be strong in You and in Your power. I will use this spiritual weapon—the Bible—by reading it and speaking it over my life. Today I give You my worries and cares. Today I choose not to worry about anything and, instead, I will tell You what I need and thank You for all You've done. I will fix my thoughts on what is true, and honorable, and right, and pure, and lovely, and admirable. I will trust in You and not in my own understanding, knowing that when I do, You will direct me. Father, You said I can pray for anything and, if I believe that I receive it, I will have it. I believe. Father, I believe You have given me strength. I believe You have given me—Your masterpiece—purpose. I believe any spirit of fear or timidity I feel is not from You, because You gave me a spirit of power and love and self-control. You said it and I believe it. You said You are with me. When I feel brokenhearted, You will heal me and bandage my emotional wounds.

When I feel overwhelmed, I will believe and accept that overwhelming victory is mine through Christ Jesus. I believe that the Spirit within me is greater than anything physical or emotional I will face in this world. I believe You are on my side and have given me a rich and satisfying life. I believe You love me and that nothing will ever separate me from that love. Thank You, Jesus. I receive from You and speak over my life joy, blessings, good, peace, power, understanding, clarity, healing, love, self-control, and overwhelming victory. I am an overcomer. In Jesus' name, Amen.

Connect with Allyson and discover more resources at
www.On3Ministries.com.

CPSIA information can be obtained
at www.ICGtesting.com
Printed in the USA
BVHW081223071122
651208BV00003B/18